RAUSCHENBERG

Rauschenberg Apogamy Pods

November 17 to December 30, 2000

PaceWildenstein
142 Greene Street New York, New York

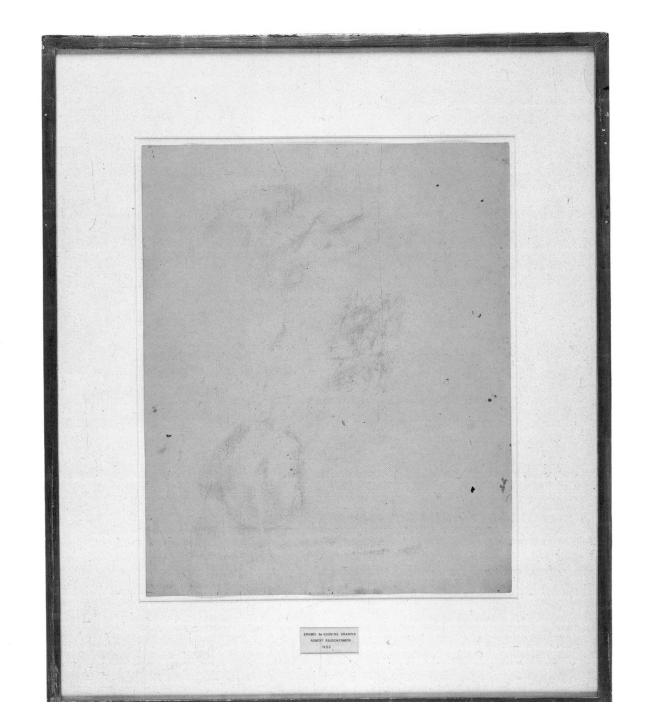

APOGAMY PODS:
RAUSCHENBERG ERASES RAUSCHENBERG

by DAVE HICKEY

I was standing on the little dock that extends into the Gulf of Mexico from the shore below Robert Rauschenberg's studio, looking west, with the jungle island of Captiva behind me. The waters of the Gulf were their customary placid taupe, streaked with magenta by the setting sun. The air was hot and close, and, somewhere out there in the mist, the tough town of Port Arthur, Texas, where Robert Rauschenberg grew up, was hugging the same flat shoreline, cooling in the same wet air. Rauschenberg completed the difficult passage from Port Arthur to Captiva more than thirty years ago. He has been on the island ever since, producing art in the jungle, plotting new ways of producing more art in the jungle, and looking back across the water toward the place from whence he came. It is not *that* far away, so, I found myself thinking about Rauschenberg's unapologetic "Southern-ness"—about his legendary charm and careless generosity, of course, but also about the tropical profusion of his work and the organic logic of his practice.

The Northern cliché, of course, is that the tropical South encourages the growth of just about everything except the human spirit. The truth is that those human spirits that *do* grow in the tropics—the spirits that flourish and prevail—almost invariably do so by mimicking its riotous ecology, by creating some simulacrum of its feral, protean bio-economics. Robert Rauschenberg is no exception. Like William Faulkner and Thomas Wolfe before him, like Louis Armstrong and Duane Allman, as well, Rauschenberg has brought into being his own, intricate jungle of the imagination according to a creative agenda that has more in common with that of Luther Burbank than with any American artist. For the first ten years of his career, Rauschenberg cleared the land with a series of draconian, reductive gestures: with house-paint and blueprints, tire prints and white paintings, black paintings and red paintings. He concluded this project by erasing a drawing of Willem de Kooning's, layer by layer—an endeavor that was more about *ingesting* de Kooning's practice than destroying his drawing—an act of internalizing de Kooning as a farmer might enrich his fields with the remnants of last year's crop.

(opposite) Robert Rauschenberg
ERASED DE KOONING , 1953
traces of ink and crayon on paper, with mat and label hand-lettered in ink, in gold-leafed frame
$25\frac{1}{2}$ x $21\frac{3}{4}$"
San Francisco Museum of Modern Art, purchased through a gift of Phyllis Wattis

Over the next forty years, Rauschenberg created his extravagant, proliferating rain forest of art, his Yoknapataphah County. Now he is clearing the land again, this time of his own old growth. These days, Rauschenberg is erasing Rauschenberg. Back in the studio, a few minutes earlier, the artist had opened a large dictionary on a stand to the word "apogamy" and read out the definition for me:

> "Apogamy," he declaimed, "asexual reproduction, agamogenesis; specifically in ferns and other cryptograms; the production of a perfect plant directly from a bud on the prothallus instead of the usual sexual process."

When I looked mystified, he explained, "Ferns around here reproduce like that, asexually, and I wanted these paintings to do that—to grow out of themselves, to contain their own contradictions and get rid of narrative, which is the sex of picture-making. Usually, the images in my paintings make narratives whether I intend them to or not. They have that kind of logic. In these paintings, I was really *trying* not to make narratives, to keep the images apart and have them relate the way real memories relate to one another, by their look, by their shape or their transparency, by their colors and their atmospheres. It was *very* hard to do. The hardest thing since I erased Bill's drawing."

"But these are all pictures of the South," I said, "You could travel east or west from where we stand, all the way around the world, and find most of these pictures on this latitude."

"Well, that's not narrative," Rauschenberg said, "That's just me. I'm a Southern boy."

"The paintings look Southern too," I said, "like frescoed graffiti on dun plaster walls, like Italy or Marraketch or Mexico."

"Not totally unintentional," Rauschenberg said.

"They also look sixtiesy," I said, "You know, cool and reductive."

"Cool is good," Rauschenberg said with the inflection of a teenager.

We were standing with our backs to the windows, on the gulf side of a blazing white, 40 x 80 foot room. The space was populated with the rolling tables upon which the artist assembles his paintings. There was a catwalk overhead from which he could look down upon the images he was assembling (and would if he didn't hate the height). We were chatting and smoking cigarettes while two art-handlers/gardeners hauled new paintings out of storage and hung them on the long wall opposite. We would look at them, and the art handlers would switch them out with more new paintings. While Raushenberg and I were looking at paintings, Bradley Jeffries, the artist's chief administrator,

was answering the phone in the kitchen; Rauschenberg's bookkeeper, Pam Schmidt was coming in and out with papers, questions and messages.

Downstairs in the shop, Lawrence Voytek and his assistants were working on Rauschenberg's painting-supports. Heavy sheets of archival paper were being vacuum-bonded to a polylaminate backing. Rauschenberg's custom-designed aluminum extrusions were being cut and welded into frame-stretcher structures upon which the paper-polylaminate sheets would ultimately be mounted. In the long computer room off the north end of the studio, Lauren Getford was printing out ink-jet transparencies from Rauschenberg's photo archives to be water-transferred to the paper/laminate surfaces as Rauschenberg required them. Standing in the midst of all this, I was buoyed up by the sense of chaotic order, by the atmosphere of intellectual ferment and joyful industry. Catching my mood, Rauschenberg looked over and grinned a very wide grin at me, as if to say, "Hey, it keeps you young." Outside, the jungle chattered and buzzed while the Gulf of Mexico just lay there, somnolent and inattentive—a healthy reminder of the world's disinterest.

Later that evening, I found myself thinking that we have almost certainly done Robert Rauschenberg a disservice by characterizing him as an "un-intellectual" artist. The connection between agamogenesis and the generative dynamics of recollection, after all, is far from a demotic analogy. Moreover, the fact that Rauschenberg has invested a lifetime of tactical and strategic understanding into the creation of a rational support system that facilitates his ongoing, instantaneous visual decision-making argues less for his lack of intellect than for his deep understanding of the position of intellect in the art-making process. We all acknowledge that the loveliness of the orchid is inexplicable, but we also know that the process of breeding the orchid, of nurturing its growth and creating the circumstances under which it might come into bloom is a matter of infinite subtlety and complexity, of detailed planning and theoretical understanding. It is not a matter of merely manipulating an object, but of manipulating the atmosphere and the energy that allows the object to come into being. Robert Rauschenberg's profound intelligence is of this tropical, botanical order.

D (APOGAMY PODS) 1999
vegetable dye transfer, acrylic and graphite on polylaminate
7'1½" x 10'½"

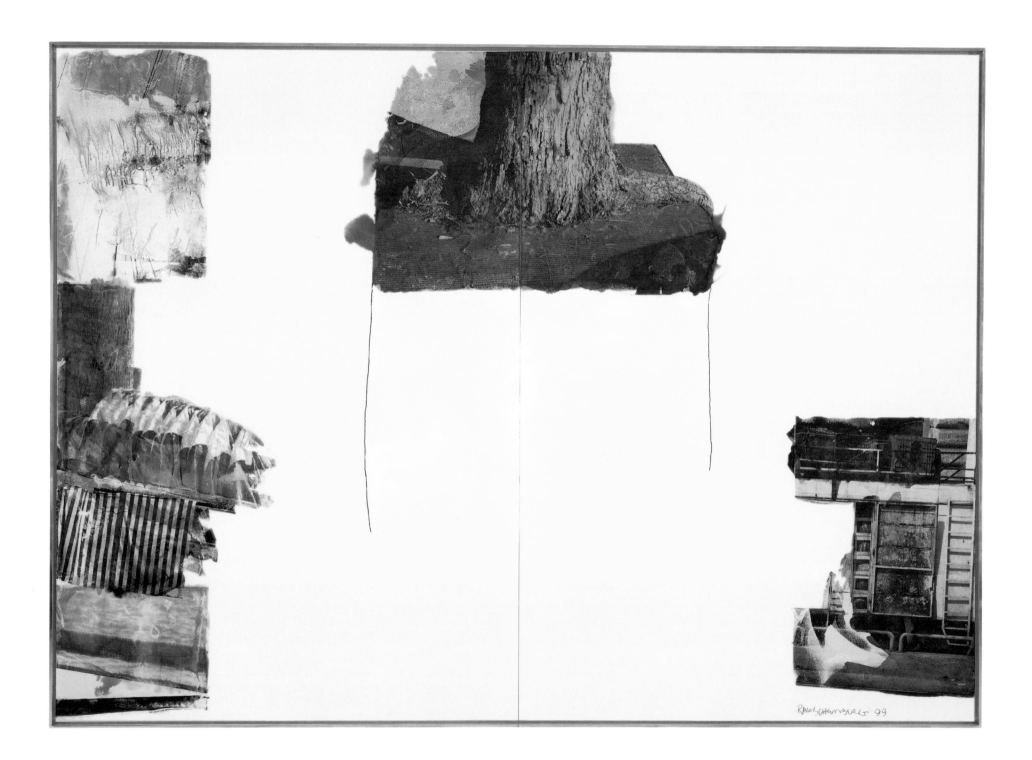

H (Apogamy Pods) 1999
vegetable dye transfer, acrylic and graphite on polylaminate
$90^3/_4$ x $85^1/_2$"

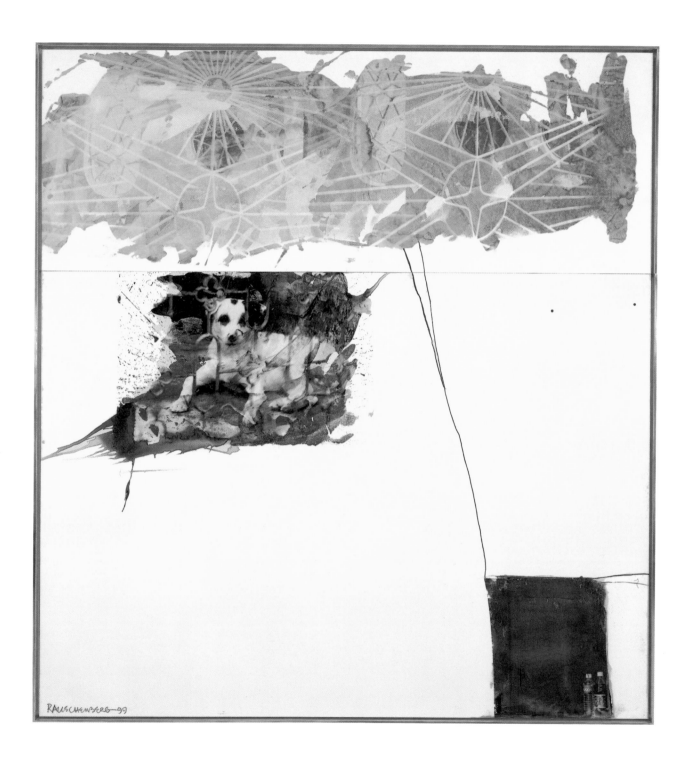

RAUSCHENBERG—99

Z (Apogamy Pods) 2000
vegetable dye transfer, acrylic and graphite on polylaminate
$85\frac{1}{2}$ x $92\frac{5}{8}$"

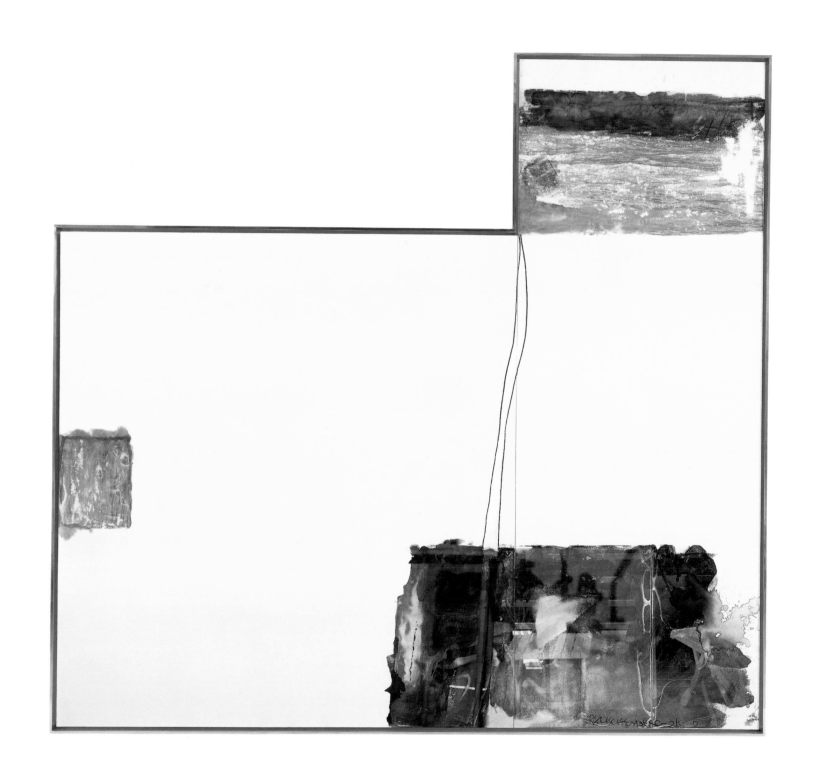

B (APOGAMY PODS) 1999

vegetable dye transfer, acrylic and graphite on polylaminate

7'1½" x 10'½"

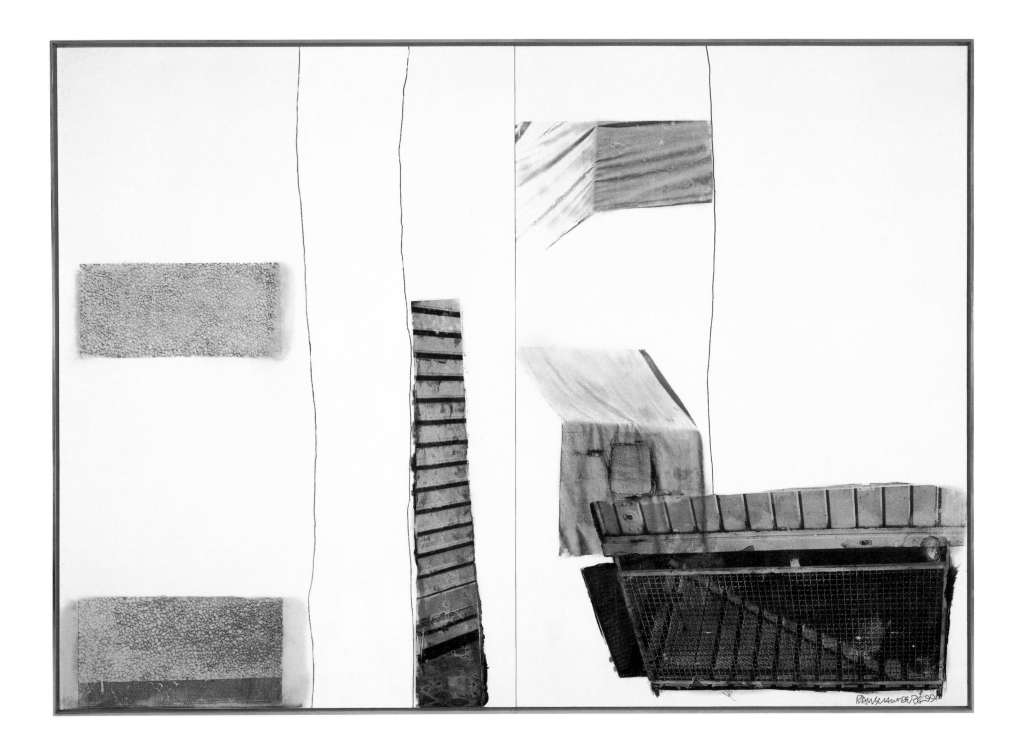

I (APOGAMY PODS) 1999
vegetable dye transfer and graphite on polylaminate
85$\frac{1}{2}$ x 86$\frac{3}{4}$"

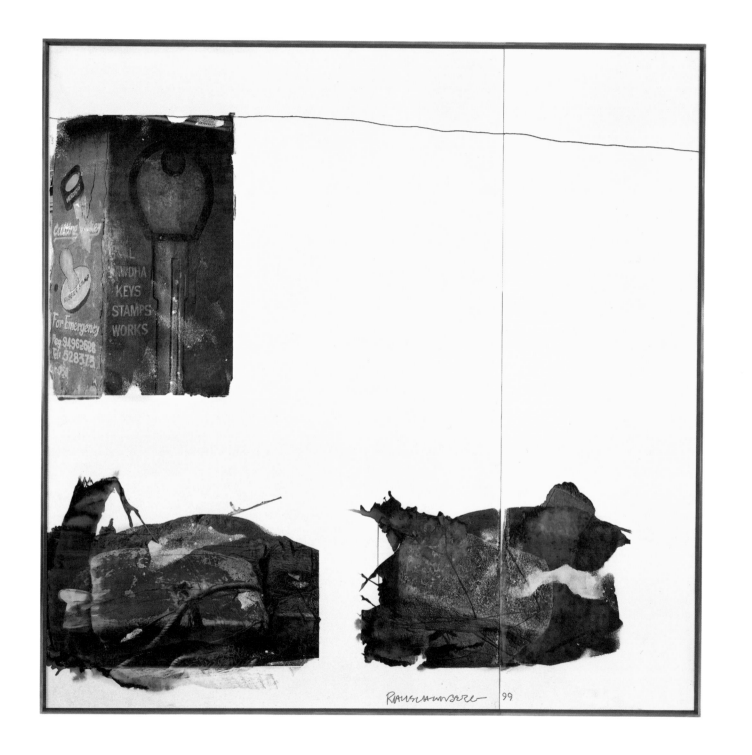

V (Apogamy Pods) 2000

vegetable dye transfer, acrylic and graphite on polylaminate

7'1½" x 15'3¼"

(overleaf) LL (Apogamy Pods) 2000

vegetable dye transfer and graphite on polylaminate

85½ x 31½"

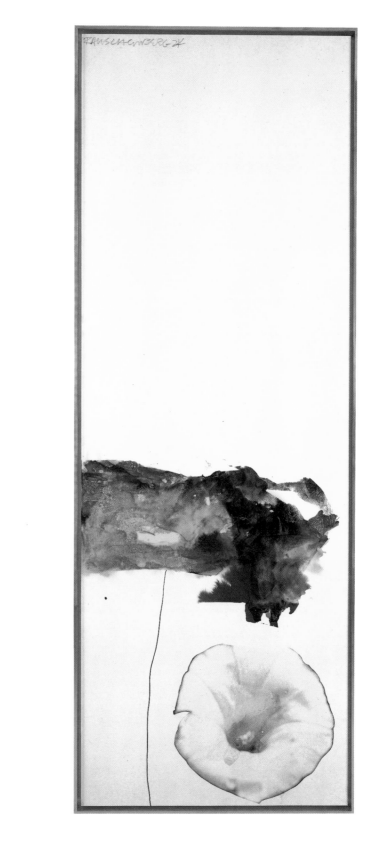

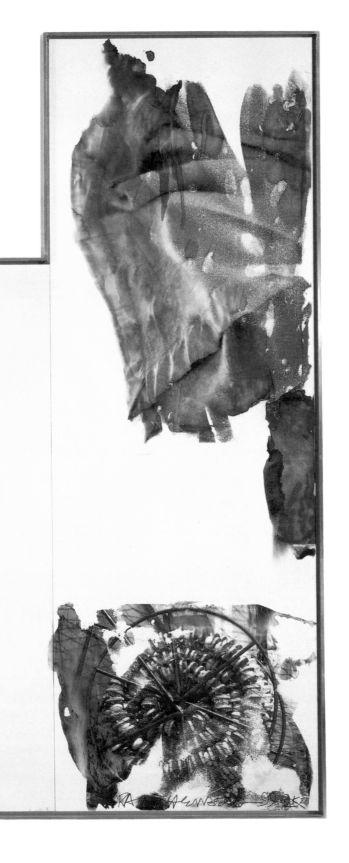

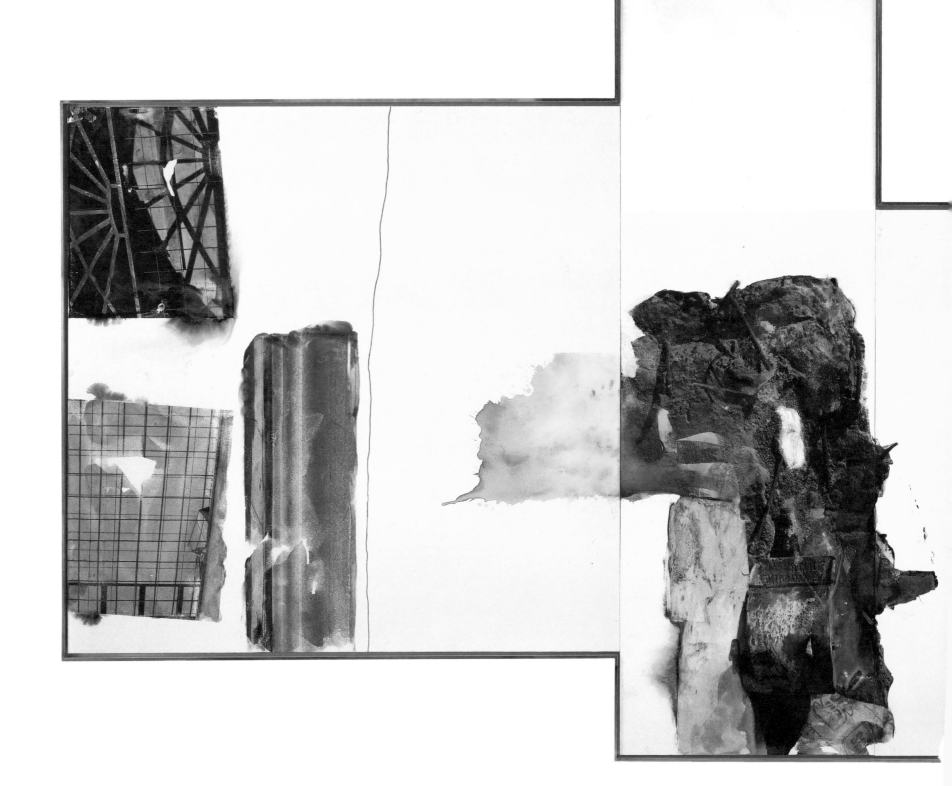

L (Apogamy Pods) 1999
vegetable dye transfer and graphite on polylaminate
85$\frac{1}{2}$ x 90$\frac{1}{2}$"

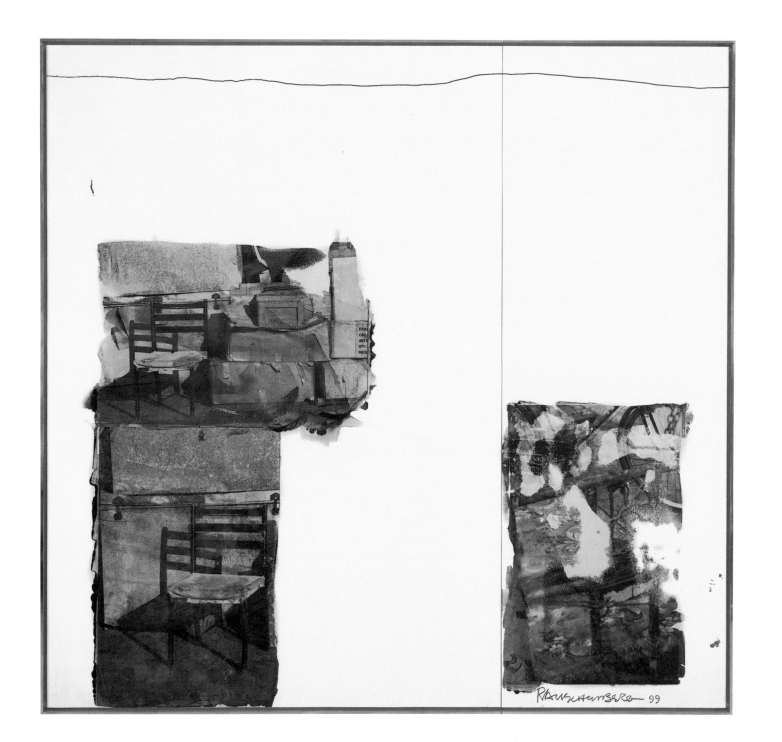

E (Apogamy Pods) 1999
vegetable dye transfer, acrylic and graphite on polylaminate
7'1½" x 8'5½"

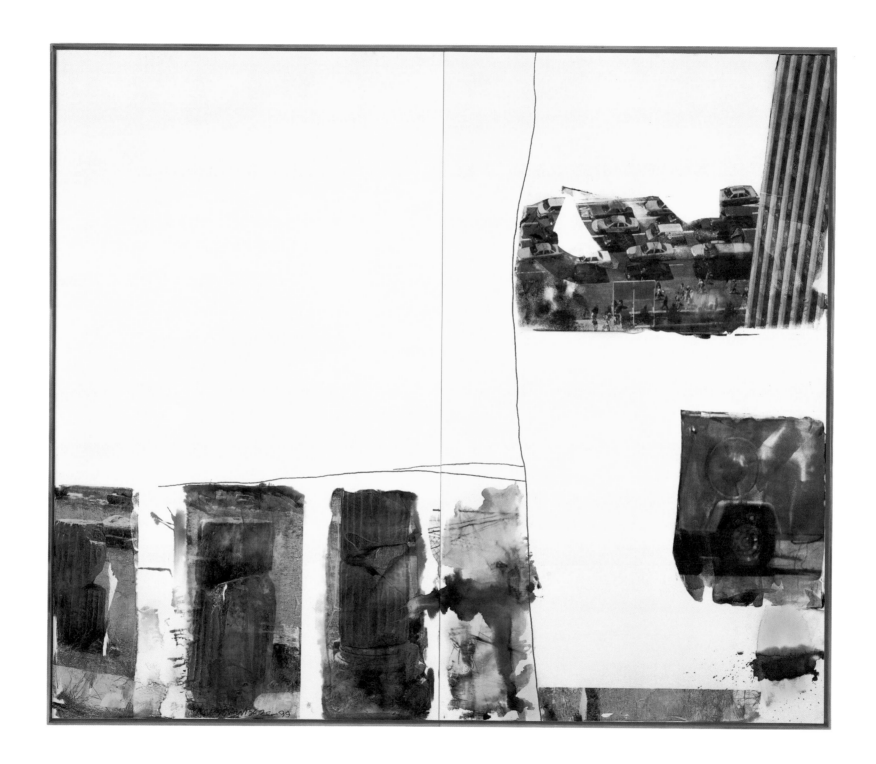

P (APOGAMY PODS) 1999
vegetable dye transfer, acrylic and graphite on polylaminate
7'1½" x 12'7¼"

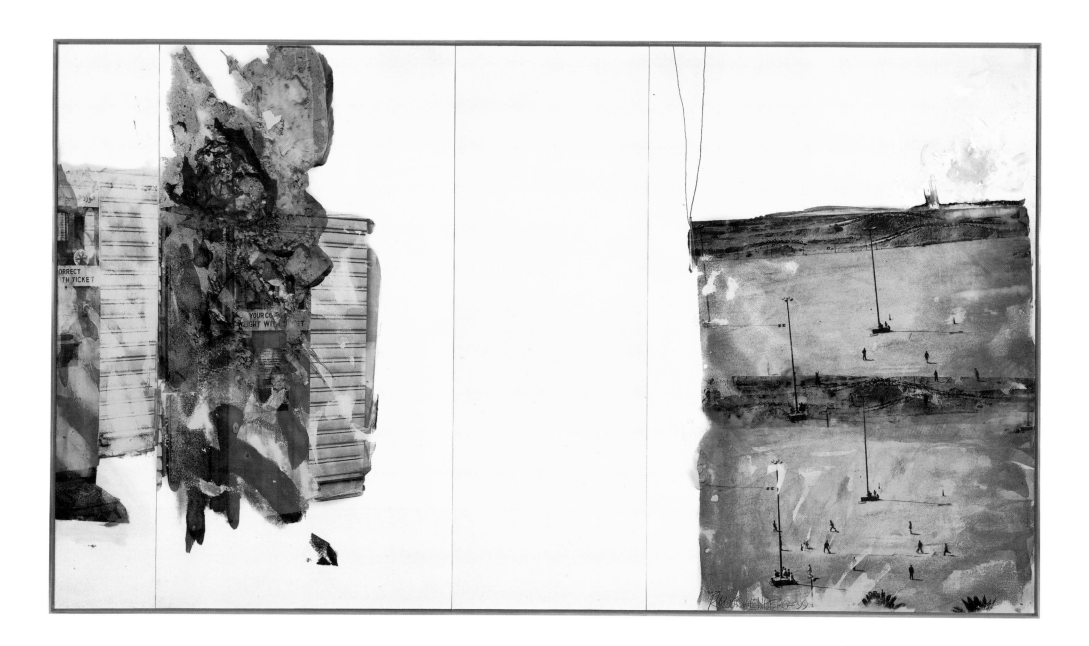

II (APOGAMY PODS) 2000
vegetable dye transfer, acrylic and graphite on polylaminate
9'7½" x 11'⅛"

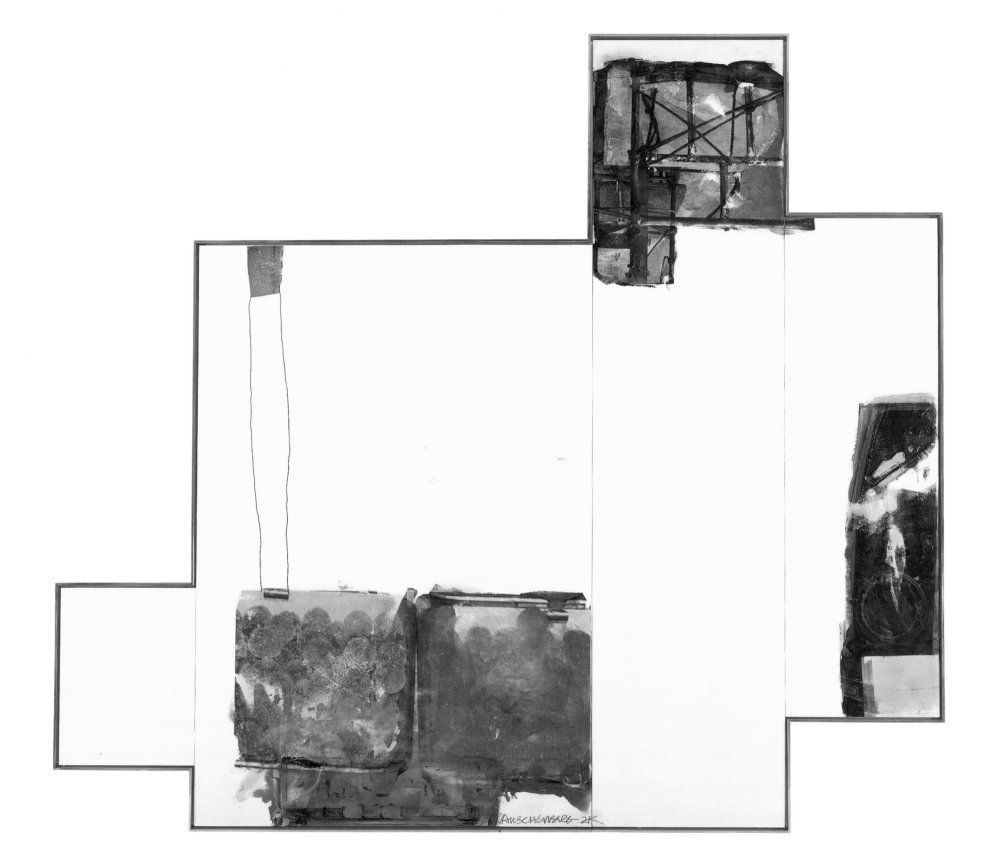

N (APOGAMY PODS) 1999
vegetable dye transfer, acrylic and graphite on polylaminate
85½ x 90½"

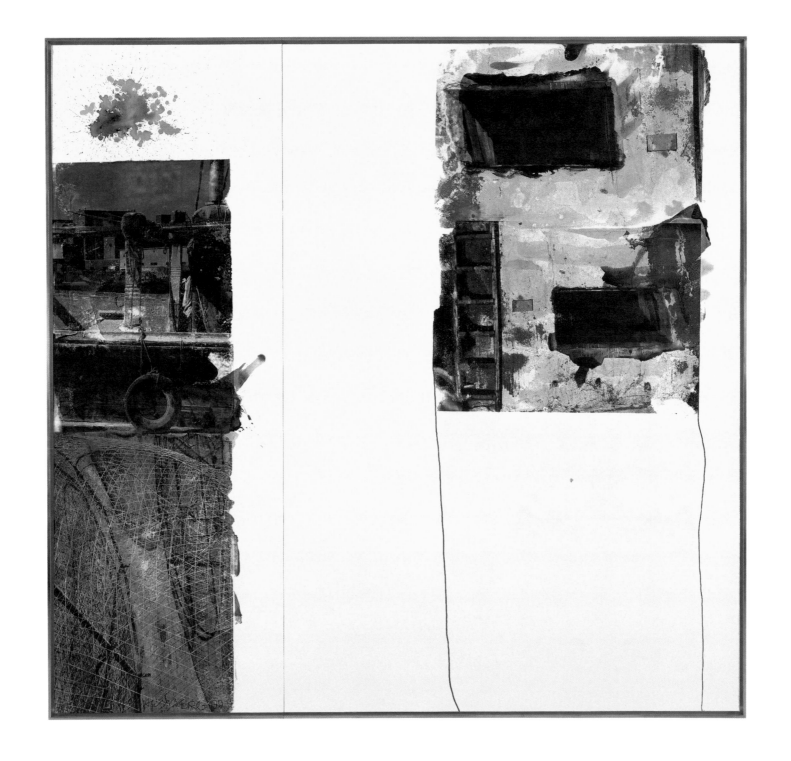

F (APOGAMY PODS) 1999
vegetable dye transfer and graphite on polylaminate
7'1½" x 10'½"

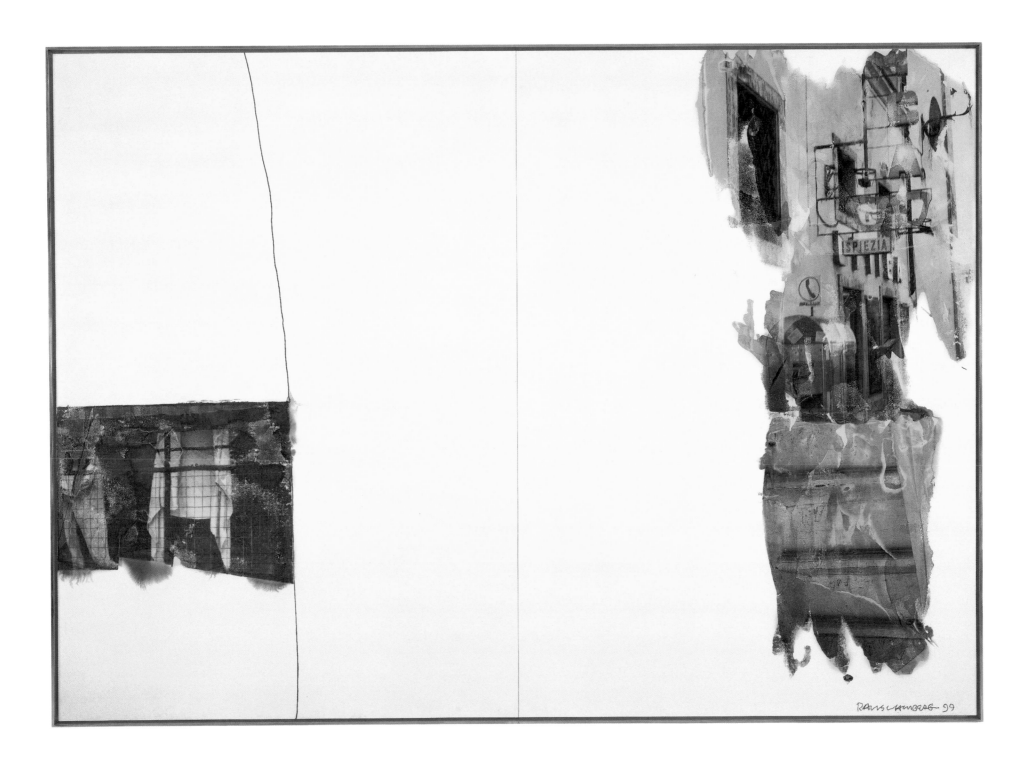

Y (Apogamy Pods) 2000
vegetable dye transfer, acrylic and graphite on polylaminate
80$\frac{1}{4}$ x 85$\frac{1}{2}$"

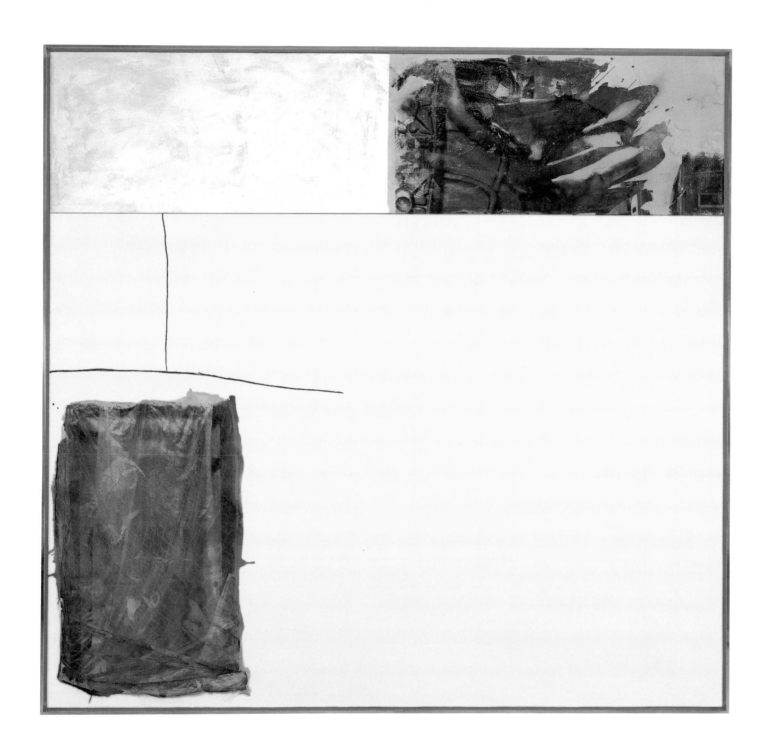

O (APOGAMY PODS) 1999

vegetable dye transfer and graphite on polylaminate

7'1½" x 10'½"

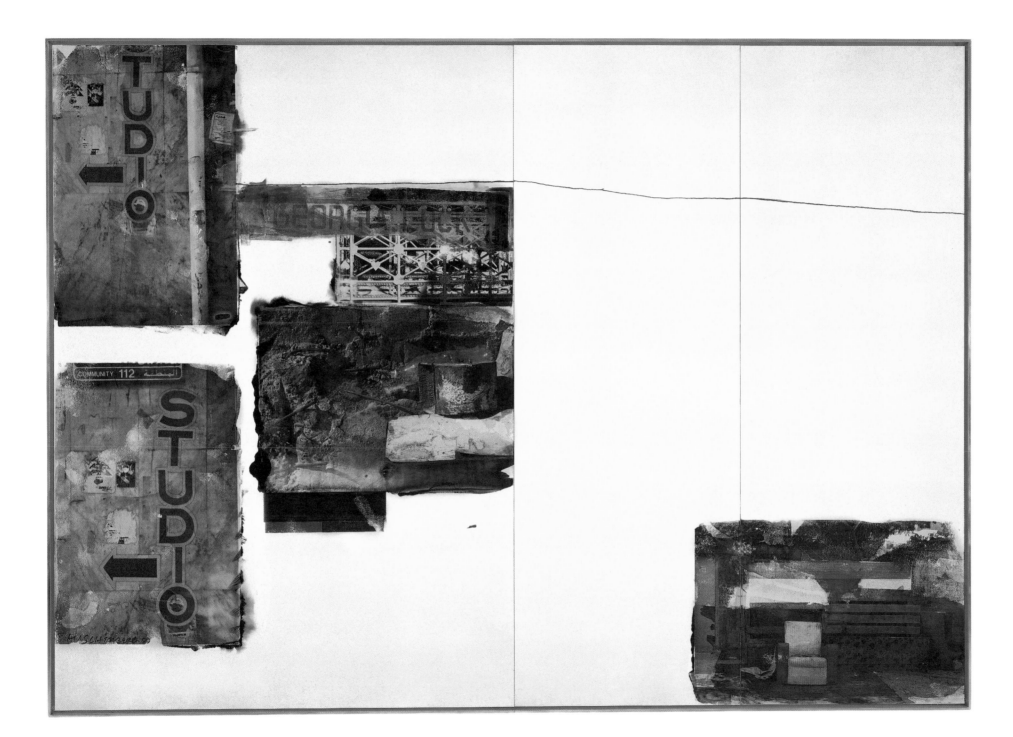

ISBN: 1-930743-01-7